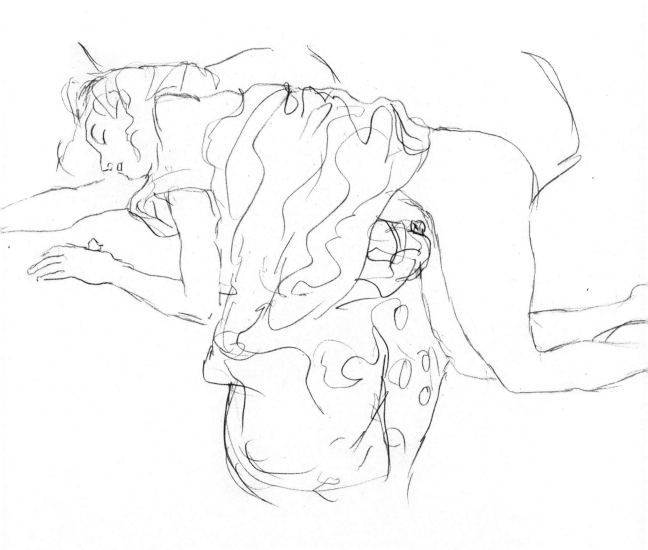

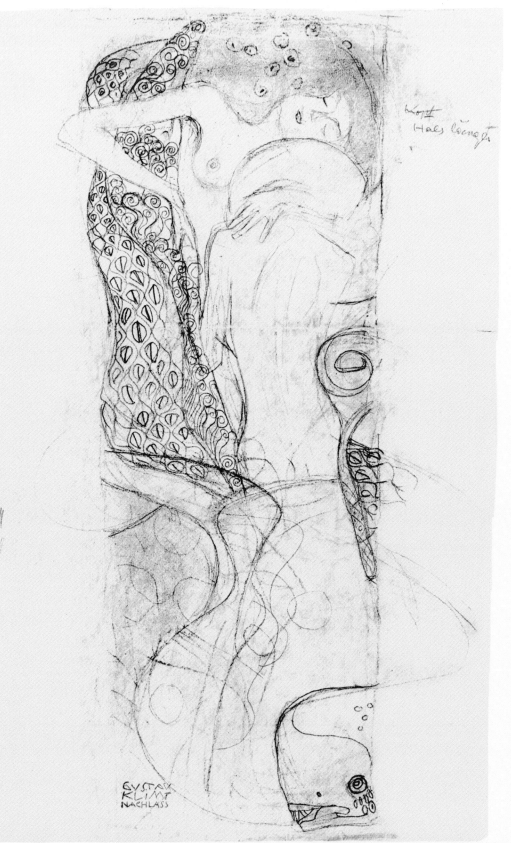

Erotic Sketches
Erotische Skizzen

GUSTAV KLIMT

Prestel

Munich · Berlin · London · New York

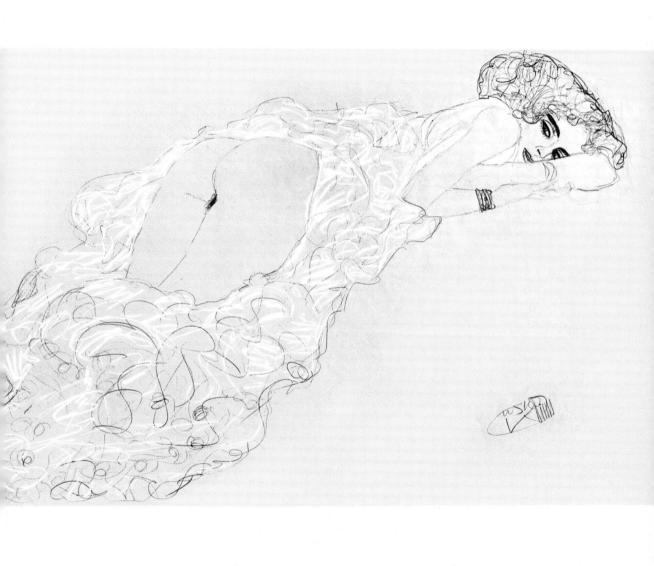

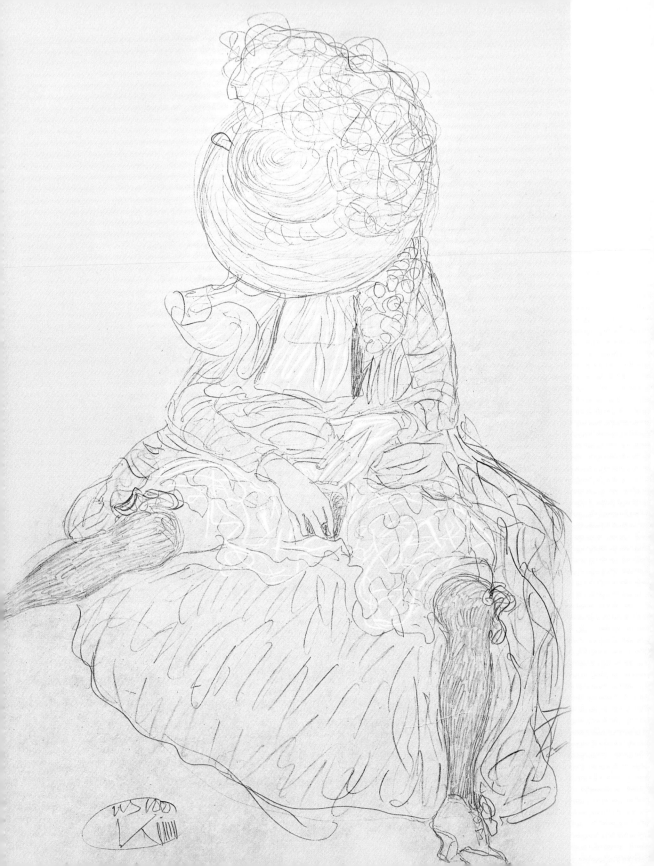

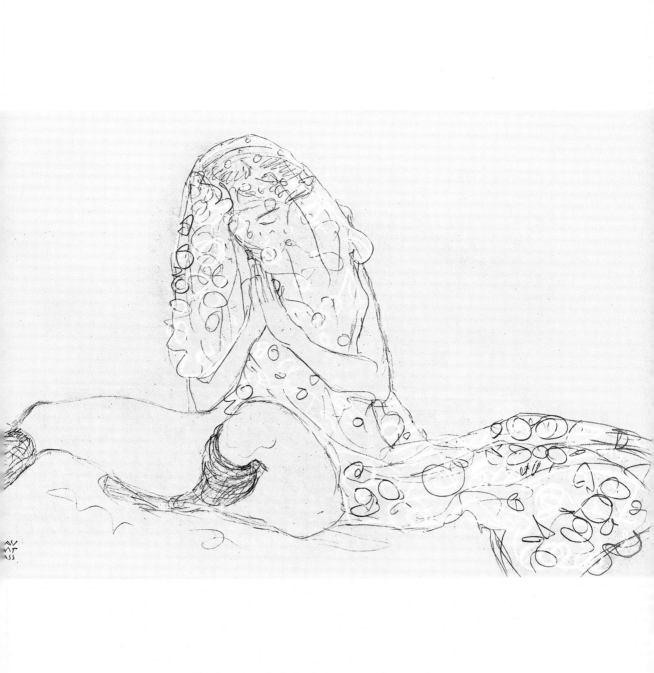

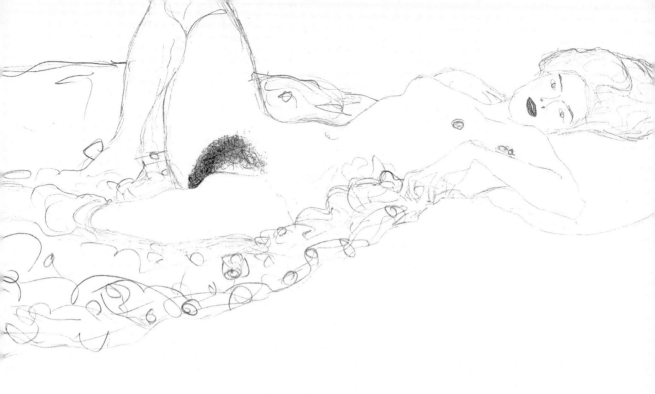

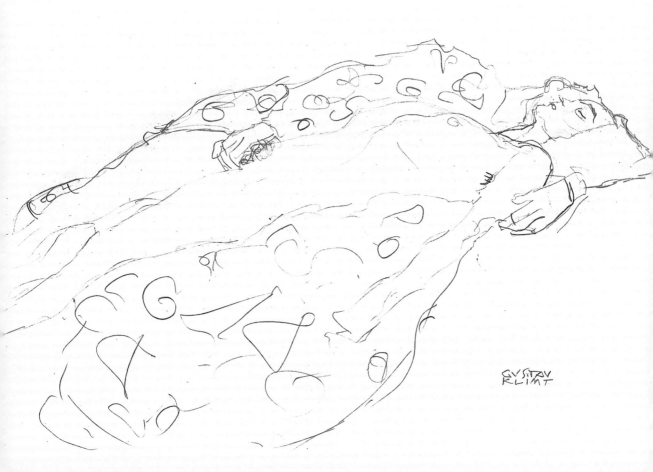

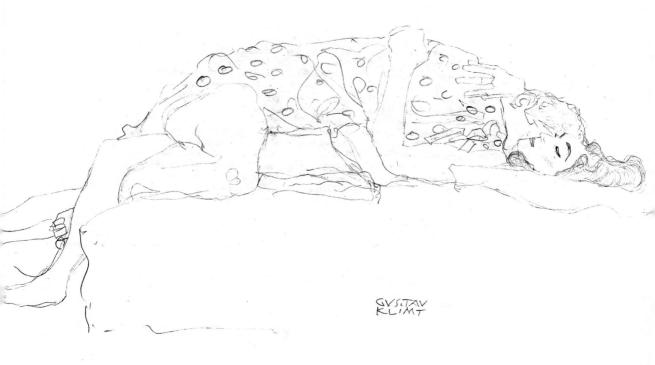

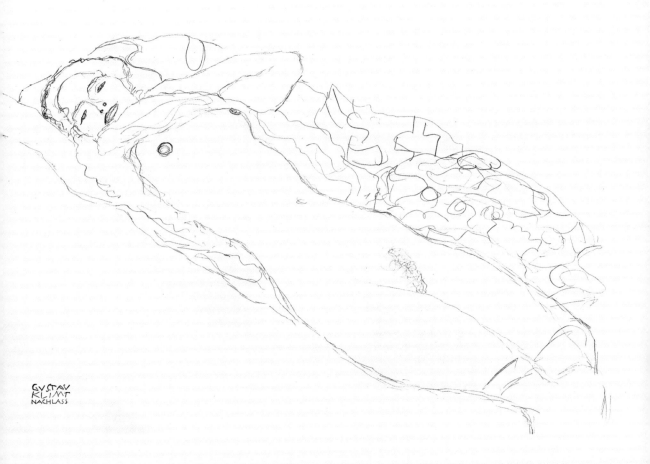

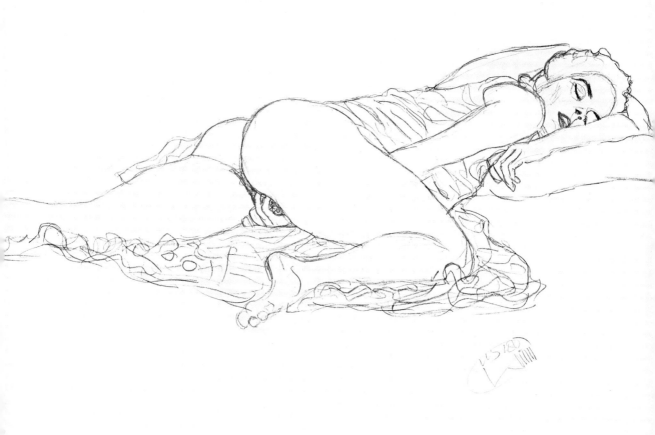

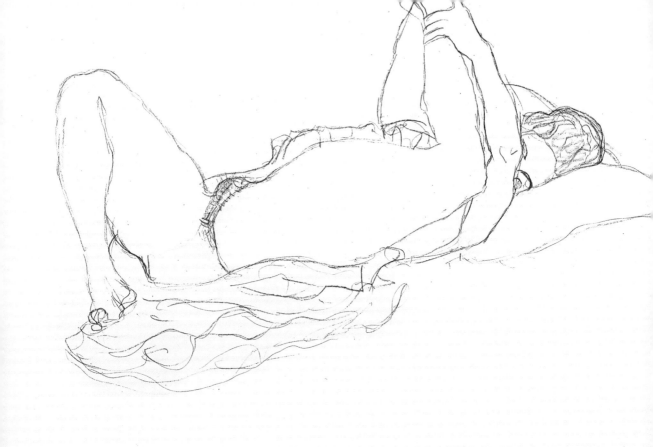

GVSTAV
KLIMT
NACHLASS

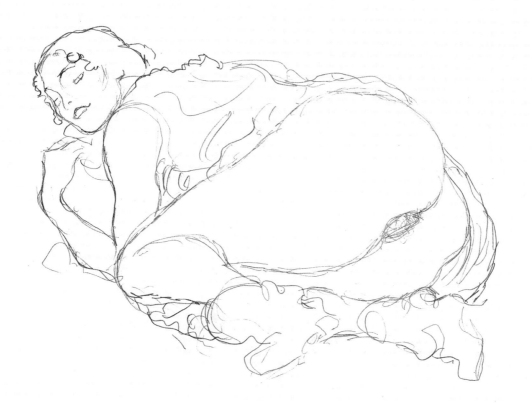

GUSTAV
KLIMT

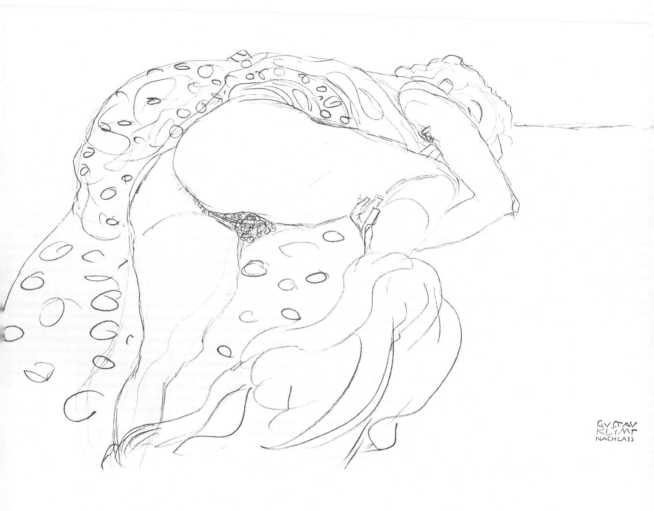

GVSTAV
KLIMT
NACHLASS

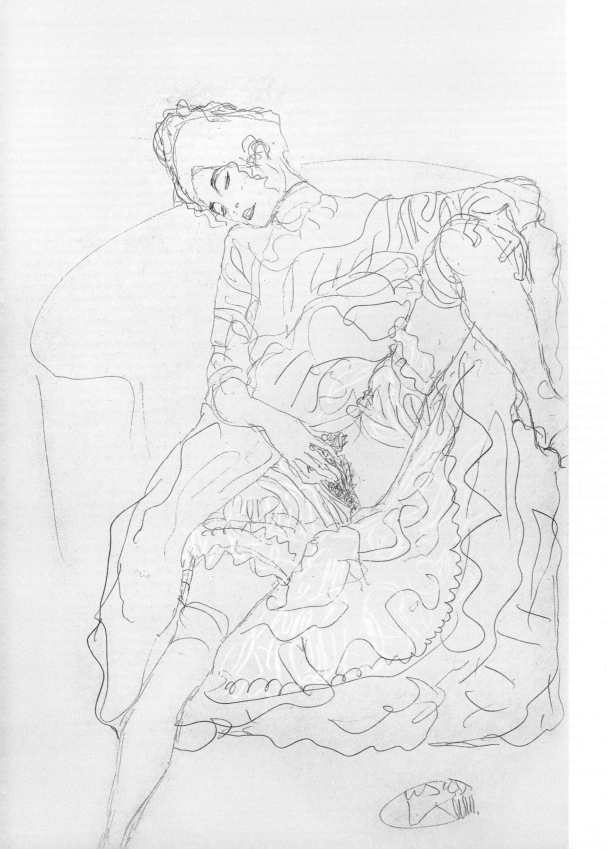

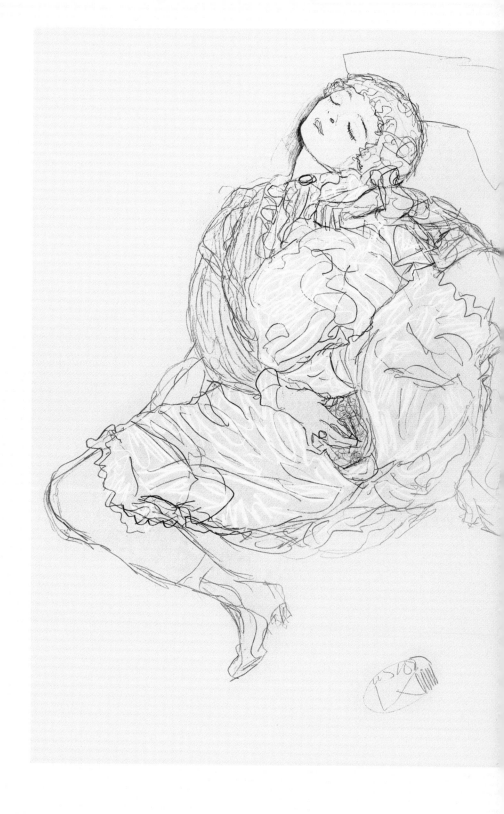

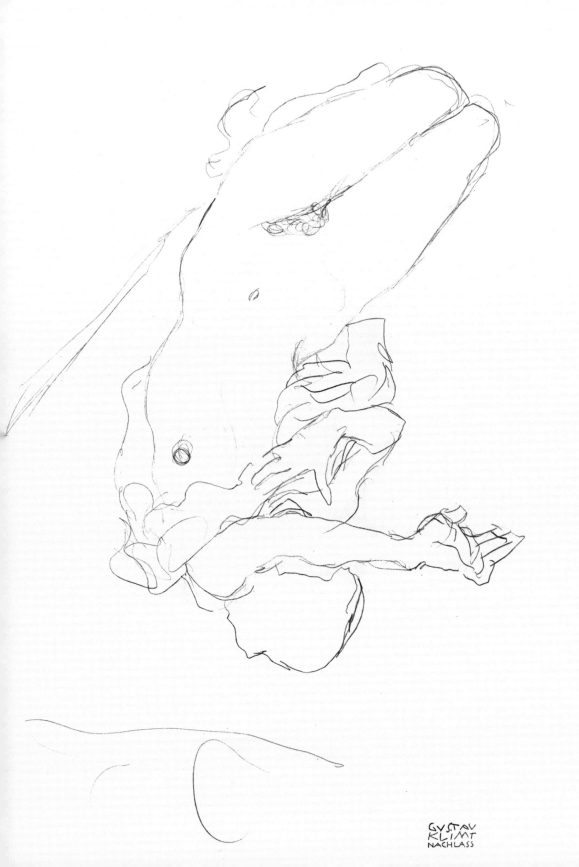

GVSTAV
KLIMT
NACHLASS

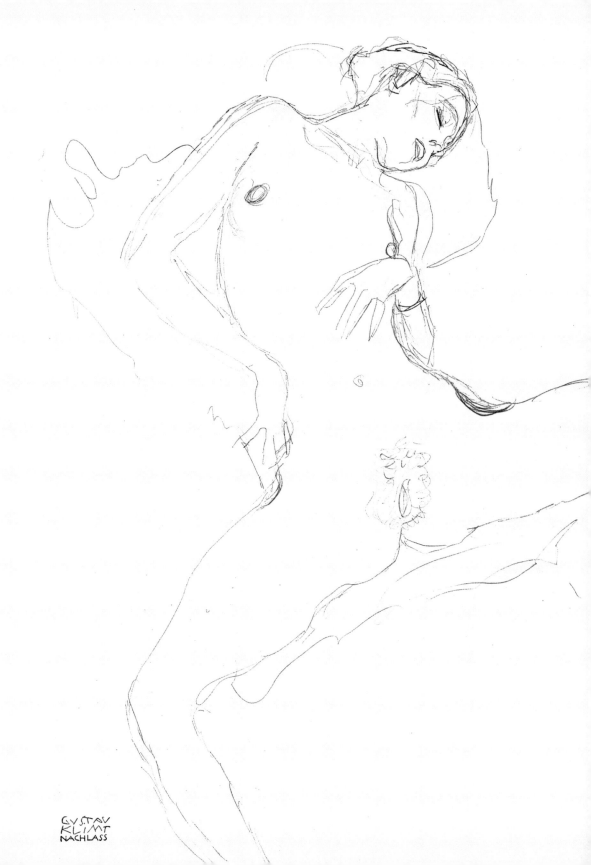

GVSTAV
KLIMT
NACHLASS

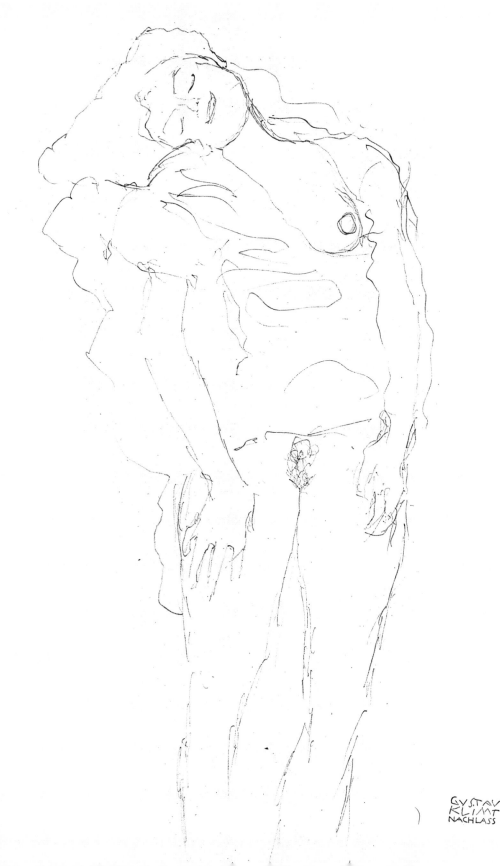

GVSTAV
KLIMT
NACHLASS

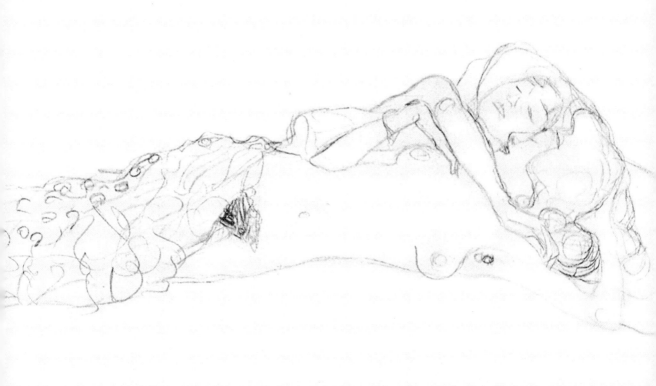

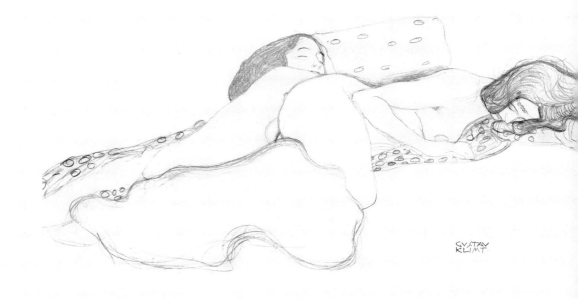

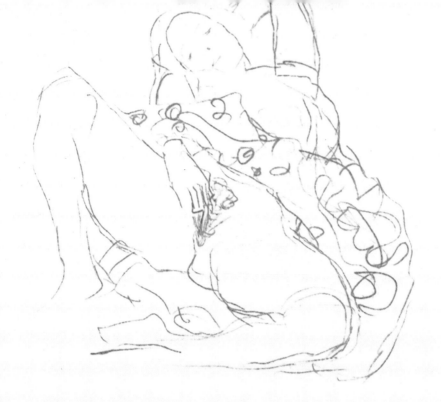

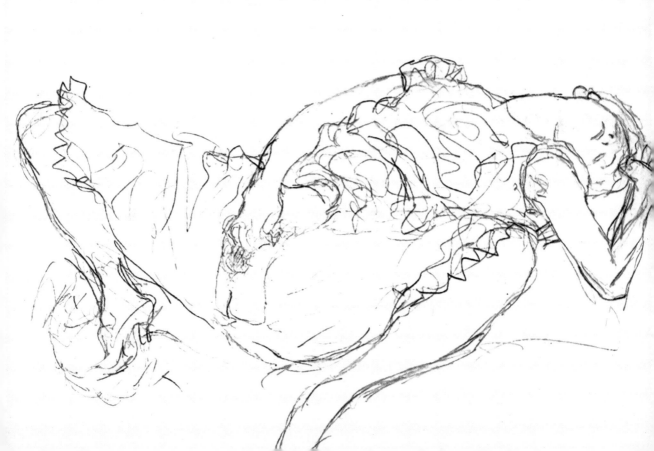

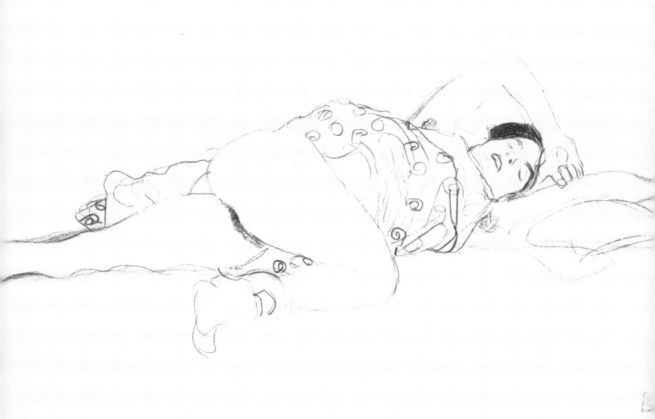

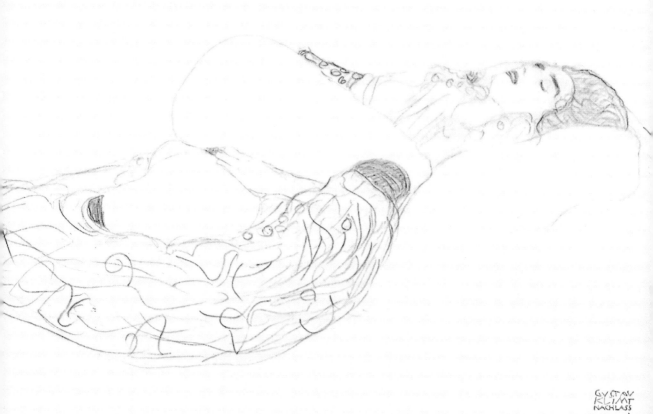

GVSTAV
KLIMT
NACHLASS

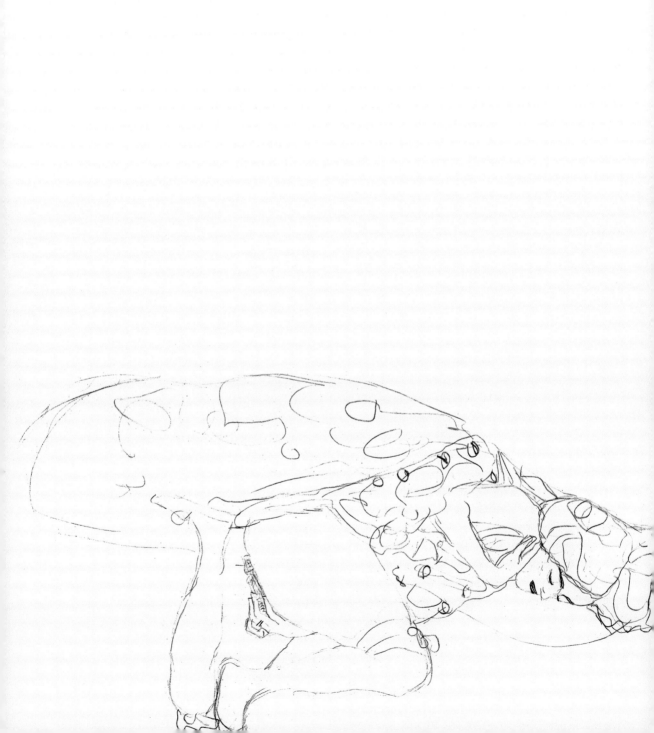

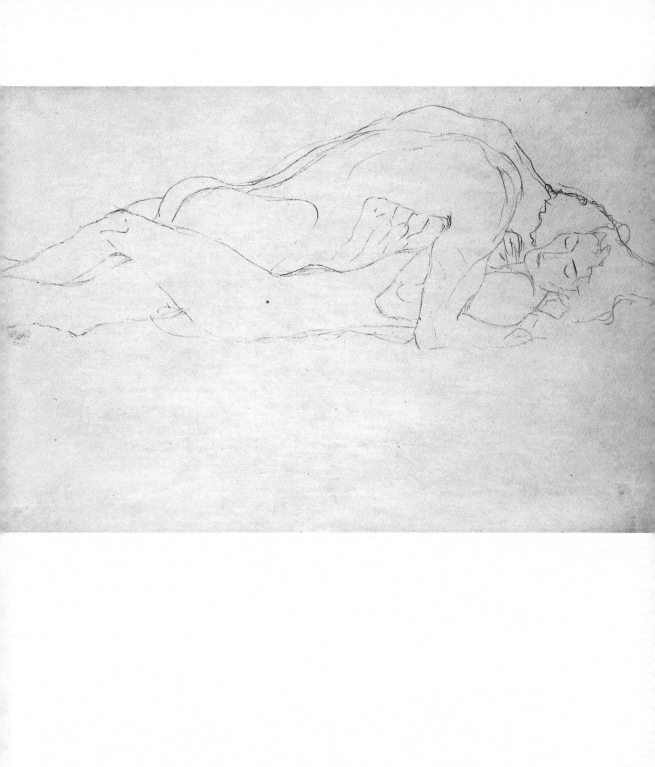

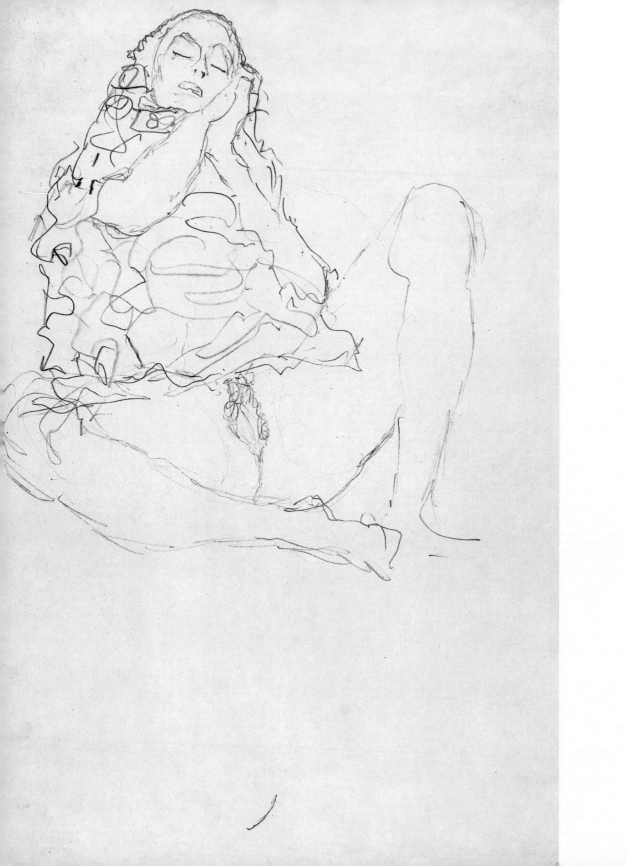

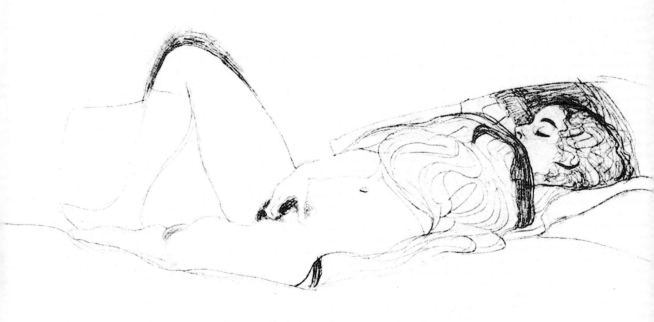

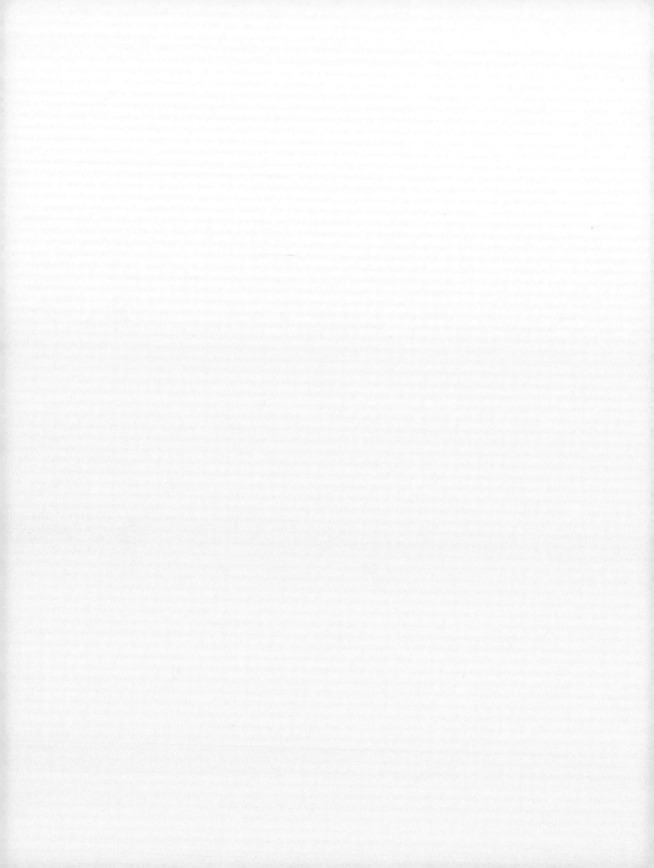

GVSTAV
KLIMT
NACHLASS

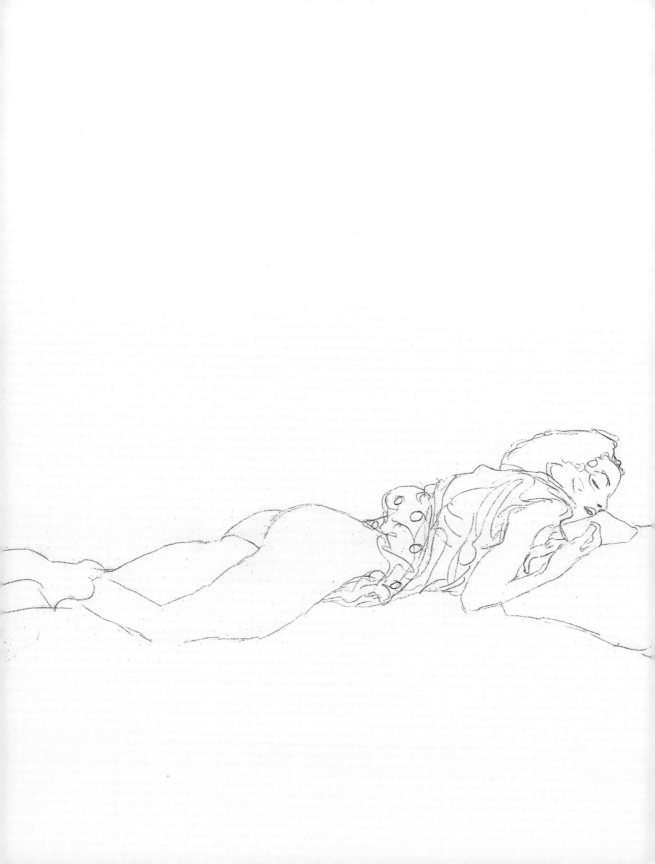

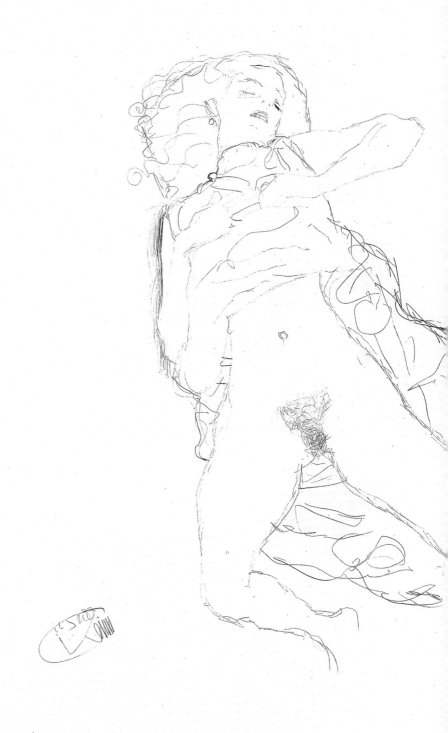

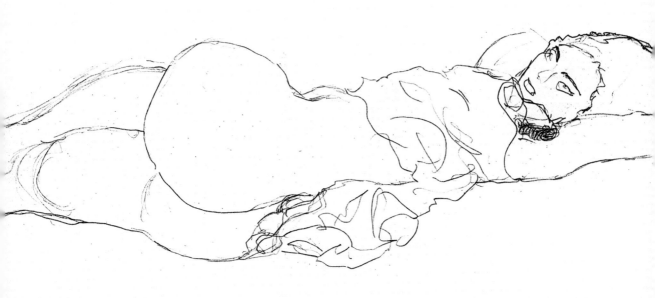

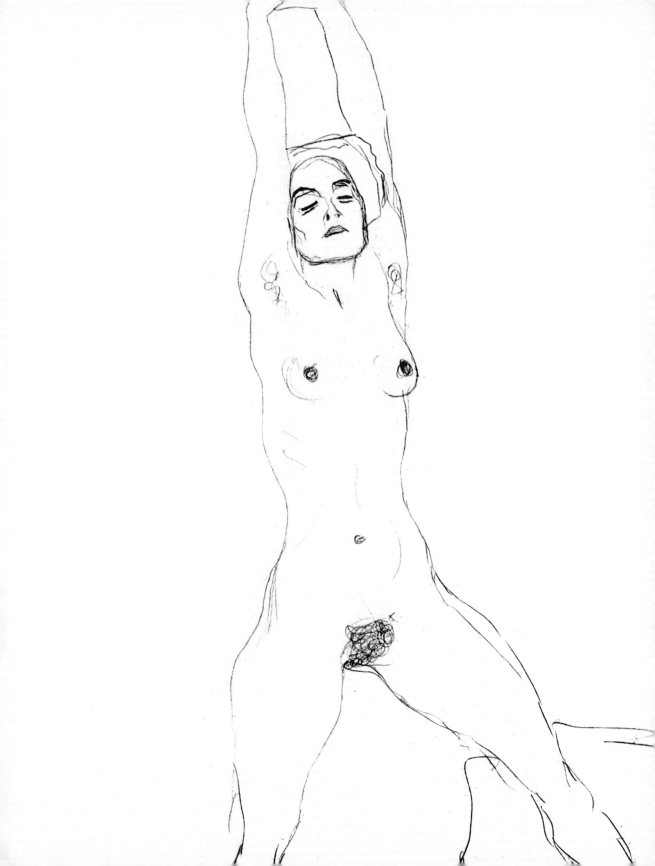

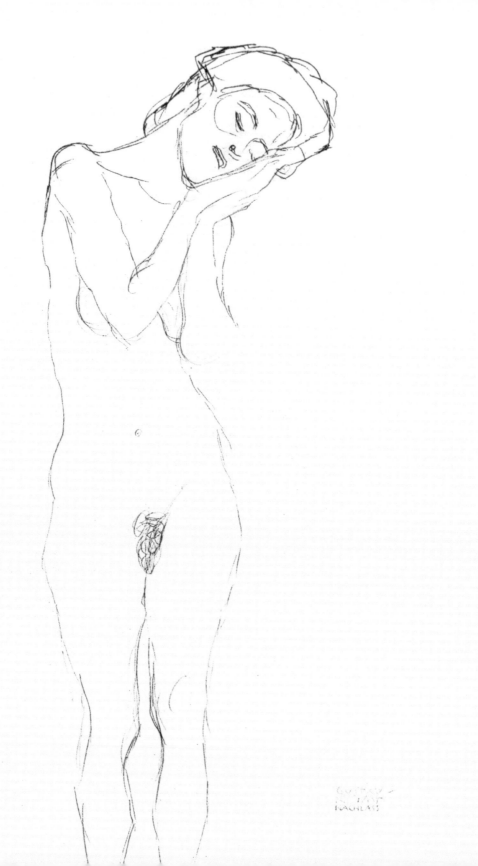

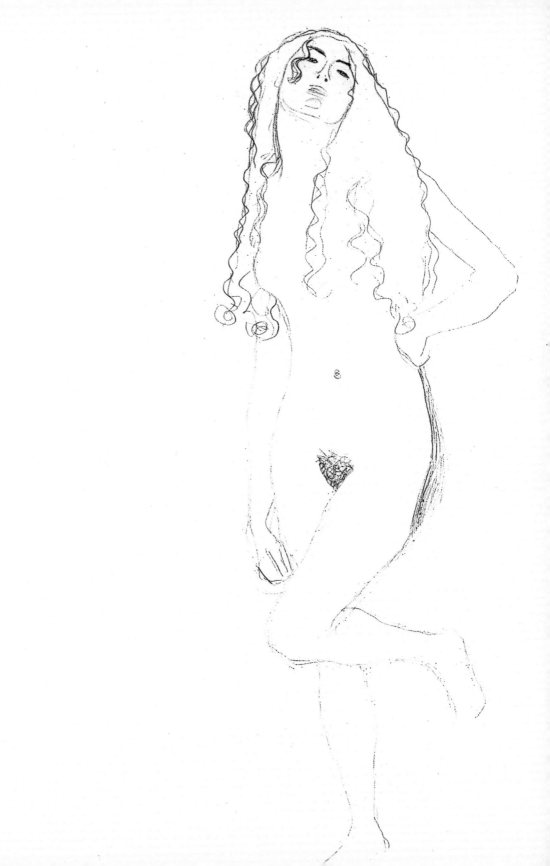

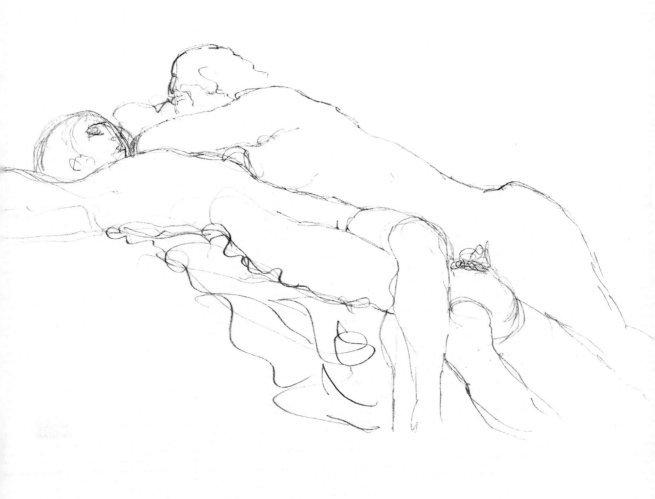

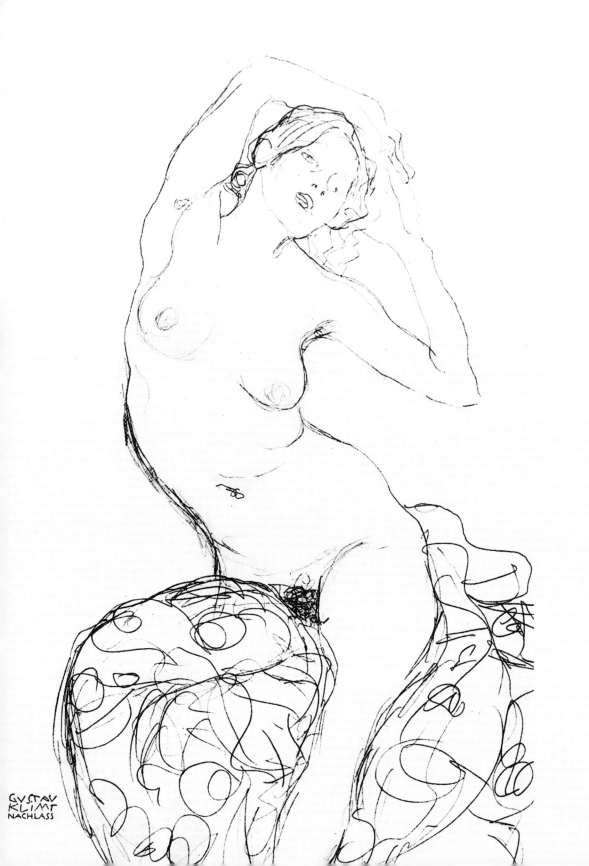

GVSTAV
KLIMT
NACHLASS

Gustav Klimt
Erotic Sketches

Norbert Wolf

Here is the only artist whose
bourgeois prudishness does not obscure nature in all its glory.

(Hermann Bahr, 1863–1934, Austrian dramatist and critic)

Fin de siècle, the end of one century, but the beginning of the next – and the birth of a new artistic style, Art Nouveau, known as *Jugendstil* in Germany and *Secessionsstil* in Austria. An overt international rebellion against the traditions of the art academies emerged. It opted for new, flowing, organically-curved shapes taken from nature which were then decoratively stylised, and focussed on new subjects related to human creativity. Art Nouveau! A magical term even today, evoking Gallé's vases, Tiffany lamps and jewellery, Symbolist subject matter, the phantasmagoria of the Catalan architect Antoni Gaudí and costly materials – in short, a symphony of elegance and extravagance.

And of course, the Viennese artist Gustav Klimt (1862–1918) is another Art Nouveau name that naturally springs to mind – the enormous sophistication of line and the decorative texture of his pictures, his attempts to sublimate and overcome the trivialities of life, and his over-arching æstheticism. In his famous painting *The Kiss* (1908, Österreichische Galerie, Vienna), an embracing couple kneel in a flowery meadow, beyond the bounds of reality, and, set against an ornamentally patterned gold background, are portrayed celebrating love as quasi-

religious communion. The couple's precious clothing appears to add jewels to the sensual tapestry.

The Secessionist style of Vienna was identifiable not just with formal subtlety and delicacy of content. It also heralded the radical experiments that the Austrian literary figure Karl Kraus summed up with the metaphor 'Test Bed of the Apocalypse'. And that was the year that the Great War broke out, burying the bliss of Art Nouveau in the trenches along with western values.

The emblemata of cultural revolution tirelessly conjured up by Karl Kraus and other intellectuals were nowhere more provocatively apparent than in the visual insurrection of the body. The art of fine linearity was connected with a visualised physicality behind whose tensions lurked the abysses of the soul – such as the psychoanalyst Sigmund Freud had discovered. For Klimt the human body had likewise become the critical vehicle of expression – particularly the graphic exploration of the naked, abandoned body in seemingly exhibitionist poses. Except in caricature and pornography, never before had Eros and sexuality been so explicitly illustrated in Austrian art as in Vienna around 1900 – and Klimt was the most inspired pioneer.

Admittedly erotic animation had always been popular in cultural circles and various subcultures. The myths of antiquity overflow with sex and sensuality. In Renaissance painting, the aroused swan writhes around between Leda's thighs, and Venus and Mars sport in bed while husband Vulcan hammers away at the anvil next door. Even the Bible admits to far more than just the Fall. Lot's daughters make their father drunk after he escapes from Sodom and then seduce him, while Salome divests herself of all her garments so as to have Herod bring the head of John the Baptist on a silver tray as a reward.

Yet the frequently scandalous state of arousal found in *fin-de-siècle* literature, theatre and art far exceeded anything previously encountered. When Nijinsky, the star dancer of the Ballets Russes, choreographed his first perform-

ance in Paris in 1912 for *Après-midi d'un Faun*, in which the faun passes a hand slowly down the body to his genitals in the closing scene, hinting at masturbation, the gesture triggered off howls of outrage from the public and a protest in *Le Figaro* the following day against the display of 'disgusting motions of erotic bestiality'. A few years later, the Viennese premiere of Schnitzler's play *La Ronde*, which presents the sex act in ten different variations, stirred up even more spectacular uproar. Stink bombs were hurled at the stage and theatre-goers smashed the fittings.

Klimt came in for his share of scandal, initially for his ceiling paintings for the ceremonial hall of the University of Vienna (destroyed in a fire in 1945), the first of which was exhibited at the Secession. Critics were less affronted by the plethora of nudes as such, than by the fact they were not idealised figures. Another hail of critical stone-throwing followed the publication of numerous drawings of nudes in the periodical *Ver Sacrum*. Guardians of public morality accused the artist of offending the eye with 'the most iniquitous artistic impudence that has ever been seen in Vienna' and living out his personal sexual obsessions under the cover of art.

More than any other medium, drawing was closest to the essentially linear nature of Art Nouveau. But it was above all in its calligraphical elements that Klimt gave shape to his most existential artistic inclinations, so successfully that many connoisseurs have deemed it one of the high points of European art and a key to Klimt's œuvre as a whole. Unquestionably it goes to the heart of Klimt's erotic orientation more than the oil paintings do, riding blithely over every taboo in its ecstasy of vision. Even in February 1966, a Roman judge declared Klimt's erotica (and similar works by Egon Schiele) to be 'obscene' and 'pornographic' and had them confiscated. These days, such drawings fetch higher prices in the international art market than any work by Klimt on other subjects.

The boundaries of what is considered acceptable have long since been pushed back, and the provocative works fall into two categories with an increasing lack of bias: Klimt's supreme artistic gift for rendering the human body – and the treatment of what was socially permitted in its day.

Knowledge of the importance of erotic psychological complexities was fast evolving in the late nineteenth century, prompting artists such as Klimt to explore the 'true' nature of man's sexual being. By depicting masturbation, homosexuality, androgyny and the battle of the sexes, Klimt was not only taking on the notorious double standards of Viennese society – he was also striving for a new authenticity of human existence. He was not a pornographic artist servicing voyeuristic proclivities. Nakedness, eroticism and sexuality enabled him to lay bare the natural propensities of human beings.

This was clearly understood by the writer Felix Salten, the anonymous author of *Josefine Mutzenbacher*, the most famous Viennese pornographic novel, who tartly remarked that Klimt's nudities mainly shocked those who sought outlets for their lechery outside art (including those who imputed homosexuality to the artist). In 1907, the writer Herman Bahr scourged the hypocritical sexual morality of the bourgeoisie, paying tribute to Klimt's sensuality in his illustrations *Dialogues of the Courtesans*: "I imbibe Klimt, the bright pagan. Those people out there who know everything, think that he is only toying with lines. You poor fools, who do not hear the nameless power of this sacred invocation of carnality! Here is the only artist whose bourgeois prudishness does not obscure nature in all its glory – the only one who sees like a pagan once more."

Indignant male critics found Klimt's treatment of a highly pregnant women disgusting and wondered what had happened to the Vienna that defeated the Turks in 1683. Hugo Ganz, the long-standing Viennese correspondent of the *Frankfurter Zeitung*, conjured up a vision of 'decent women' forced to look at Klimt's drawings (whose artistic qualities he did not dispute) and blush,

reduced by them to the level of whores. The sociology of seeing addressed here fails to recognise that Klimt's works intended for the public did not always repel a female viewer. A woman visitor to the Villa Waerndorfer for example remembers the following ritual: after tea, the mistress of the house took them over to the gallery. The maid handed her a red velvet case with a silver key. This opened a pair of double doors. Within, the highly erotic picture of *Hope* met their gaze. Clearly, it was a very private audience!

Whether Klimt consistently kept his many lesbian scenes, or the women with their legs wide apart and a finger deep between their thighs, under lock and key remains unclear to this day. Only a package of fifteen highly erotic drawings – the *Dialogues of the Courtesans* completed in 1907 – is documented as having found its way into the art trade in Klimt's lifetime. The translator of Lucian's classical text, Franz Blei, was able to select what he wanted from piles of drawings in Klimt's studio. The result was one of the most beautiful of Art Nouveau books.

Over 4,000 wonderful Klimt drawings survive, the erotic drawings being mainly works in pencil or charcoal, occasionally with the addition of coloured crayons. The bodies loll about in abandonment. But even when masturbating or in moments of ecstasy, the models preserve their composure with a kind of shameless sublimity.

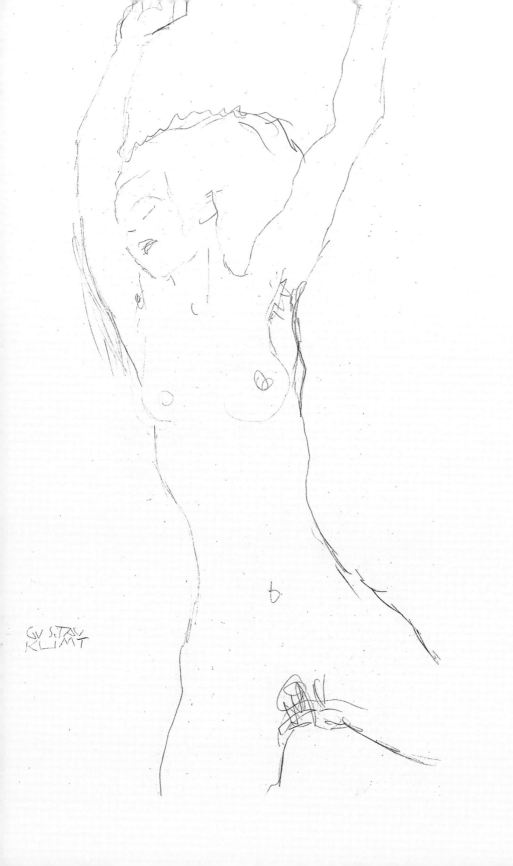

GUSTAV KLIMT
Erotische Skizzen

Norbert Wolf

»Hier ist der einzige, dem keine
bürgerliche Scham die blühende Natur
verdunkelt.« (Hermann Bahr)

Fin de Siècle, Jahrhundertende – das hieß auch Jahrhundertbeginn: Geburt eines neuen Stils. »Jugendstil« nannte man ihn in Deutschland, »Secessionsstil« sagte man in Österreich. Eine internationale Rebellion erhob sich gegen die Traditionen der Kunstakademien; wählte neue, fließende, organisch geschwungene Formen, der Natur abgeschaut und dann dekorativ stilisiert; wählte neue Inhalte, auf menschliche Kreativität bezogen. Jugendstil! Noch heute ein Zauberwort, das an Vasen von Gallé, an Schmuck von Tiffany, an symbolistische Themen, an die Phantasmagorien des spanischen Architekten Gaudì, an teure Materialien, kurz: an eine Symphonie der Eleganz und Extravaganz denken lässt.

Und natürlich denkt man an den Wiener Gustav Klimt (1862–1918): an seine enorme Schönlinigkeit und dekorative Textur seiner Bilder, an seine Versuche zur Sublimierung und Überwindung banalen Lebens, an seinen alles übergreifenden Ästhetizismus. Im berühmten Gemälde *Der Kuss* (1908, Wien, Österreichische Galerie) kniet ein sich umarmendes Paar, aller Realität entrückt, auf einer Blumenwiese, vor ornamental gemustertem Goldgrund, und

zelebriert die Liebe wie eine pseudoreligiöse Kommunion. Die pretiöse Kleidung von Mann und Frau scheint Juwelen zu sinnlichen Teppichen zu fügen.

Doch der Wiener Sezessionsstil war nicht nur identisch mit formaler Raffinesse und inhaltlicher Delikatesse. Er läutete auch jene radikalen Experimente ein, die der österreichische Literat Karl Kraus 1914 unter der Metapher »Versuchsstation Weltuntergang« zusammenfasste. Er tat dies in jenem Jahr, als der große Krieg ausbrach und mit den abendländischen Werten auch die Jugendstil-Seligkeit in den Schützengräben begrub.

Die von Karl Kraus und anderen Intellektuellen unermüdlich beschworenen Embleme kultureller Revolution zeigten sich vielleicht nirgends so provokant wie im bildlichen Aufstand des Leibes. An die Kunst der schönen Linien knüpfte sich eine visualisierte Körperlichkeit, hinter deren Spannungen die Abgründe der Seele lauerten – wie sie die Psychoanalyse Sigmund Freuds aufgedeckt hatte. So wurde auch für Klimt der menschliche Körper zum maßgeblichen Ausdrucksträger – insbesondere die gezeichnete Exploration des nackten, des sich scheinbar exhibitionistisch preisgebenden Leibes. Nie zuvor waren Eros und Sexualität in der österreichischen Kunst außerhalb der Karikatur und der Pornographie derart unverhohlen ins Bild gekommen wie in Wien um 1900 – und Klimt war der genialste Wegbereiter.

Gewiss, erotische Animation war seit jeher beliebt in Kultur und Subkultur. Die Mythen der Antike quellen über von Sex und Sinnenlust. Gerne schlängelt sich in der Renaissancemalerei der erregte Schwan zwischen die Schenkel Ledas, vergnügen sich Venus und Mars im Bett, während der Ehemann Vulkan nebenan auf den Amboss hämmert. Selbst die Bibel kennt weit mehr als den allerersten Sündenfall: die Töchter Lots beispielsweise, die den aus Sodom geflohenen Vater betrunken machen und dann besteigen, oder Salome, die sich sämtlicher Kleidungsstücke entledigt, um zum Dank das Haupt Johannes des Täufers auf dem Silbertablett serviert zu bekommen.

Doch die oft genug skandalisierten Erregungszustände, die Literatur, Theater und bildende Kunst im Fin de Siècle produzierten, übertrafen alles bisher Gewohnte. Als Vaslav Nijinsky, der Startänzer des Russischen Balletts 1912 in Paris mit »L'Apres-midi d'un faune« seine erste Choreographie präsentierte und in der Schlussszene den Faun mit der Hand langsam über den Körper zum Geschlecht streichen und eine Masturbation andeuten ließ, löste die Geste empörtes Johlen des Publikums und den Protest des »Figaro« gegen die Zurschaustellung von »ekelhaften Bewegungen erotischer Bestialität« aus. Wenige Jahre später geriet die erste Wiener Aufführung von Arthur Schnitzlers »Reigen«, in dem der Geschlechtsakt in zehnfacher Variation inszeniert wurde, zu einem noch spektakuläreren Ärgernis. Stinkbomben flogen auf die Bühne, Zuschauer zertrümmerten die Theatereinrichtung.

Auch Klimt erlebte »seine« Skandale. Den ersten Stein des Anstoßes lieferten seine Deckengemälde für den Festsaal der Universität Wien (1945 verbrannt), von denen das erste 1900 in der Secession ausgestellt wurde. Kritiker stören sich nicht einmal so sehr an den Nuditäten, als vielmehr an deren fehlender Idealisierung. Die nächste Aufregung lieferten Klimts zahlreiche Aktzeichnungen für die Zeitschrift »Ver Sacrum«. Sittenrichter warfen dem Künstler vor, das Auge durch das »Ärgste, was man von künstlerischer Unverfrorenheit in Wien gesehen hat«, zu beleidigen und unter dem Deckmantel der Kunst seine persönlichen sexuellen Obsessionen auszuleben.

Stärker als jedes andere Medium korrespondierte die Zeichnung mit der linearen Grundhaltung des Jugendstils. Doch gerade in ihrer Kalligraphie verwirklichte Klimt seine existentiellsten künstlerischen Anliegen, so sehr, dass sie vielen Kennern als einer der Höhepunkte europäischer Kunst und als Schlüssel zum Gesamtwerk Klimts galten und gelten. Unbestreitbar trafen sie mehr als die Ölbilder den Kern der erotischen Konfession Klimts, gingen in ihren Ekstasen des Sehens über jedes Tabu hinweg. Noch 1966 bezeichnete im Februar ein

römischer Sittenrichter Erotika von Klimt (und solche von Egon Schiele) als »obszön« und »pornographisch« und ließ sie beschlagnahmen. Heute erzielen diese Blätter höhere Preise am internationalen Kunstmarkt als jede Arbeit Klimts zu anderen Themen.

Die Grenzen des Zumutbaren haben sich längst verschoben, die Grenzgänge sondieren immer unvoreingenommener zwei Felder: Klimts überragendes künstlerisches Niveau bei der Wiedergabe gerade des nackten Körpers und die zeittypische Umgehensweise mit dem gesellschaftlich Sanktionierten.

Vor dem Hintergrund eines im späteren 19. Jahrhunderts aufbrechenden Wissens um die Bedeutung erotischer Tiefenschichten entdeckten auch Künstler wie Klimt in der sexuellen Natur die »wahre« Natur des Menschen. Mit der Darstellung von Masturbation, Homosexualität, Androgynie und Geschlechterkampf ging Klimt nicht nur gegen die berüchtigte Doppelmoral der Wiener Gesellschaft an, er suchte auch nach einer neuen Authentizität menschlicher Existenz. Er war kein Pornograph, der voyeuristische Neigungen bedienen wollte. In Nacktheit, Erotik, Sexualität legte er die natürliche Befindlichkeit des Menschen frei.

Der Schriftsteller Felix Salten, anonymer Autor der »Josefine Mutzenbacher«, des berühmtesten Wiener Pornoromans, wusste und kritisierte, dass die Nuditäten Klimts vor allem jene Zeitgenossen schockierten (es waren auch die, die dem Künstler Homosexualität andichteten), die sich außerhalb der Kunst ungeniert Ventile ihrer Lüsternheit suchten. Der Schriftsteller Hermann Bahr geißelte die verlogene Sexualmoral des Bürgertums, indem er 1907 der Sinnlichkeit Klimts, etwa in dessen Illustrationen der »Hetärengespräche«, huldigte: »Ich trinke Klimt, den hellen Heiden. Die da draußen, wo sie alles wissen, glauben, dass er nur mit Linien spiele. Arme Toren, dass ihr die namenlose Macht dieser heilig schwörenden Geilheit nicht vernehmt! Hier ist der einzige, dem keine bürgerliche Scham die blühende Natur verdunkelt. Der einzige, der wieder heidnisch blickt.«

Entrüstete männliche Kritiker empfanden das Motiv der Hochschwangeren bei Klimt als degoutant und sorgten sich, wo denn dabei das Wien bleibe, das 1683 die Türken besiegt habe; Hugo Ganz, der langjährige Wien-Korrespondent der »Frankfurter Zeitung«, sah durch Klimts Zeichnungen – deren künstlerische Qualität er nicht bestritt - »anständige Frauen«, die sie errötend anschauen müssten, auf eine Stufe mit Dirnen gestellt. Die Soziologie des Sehens, die hier angesprochen ist, verkennt, dass Klimts für die Öffentlichkeit bestimmte Werke ein weibliches Publikum nicht immer abstießen. Eine Besucherin der Villa Waerndorfer erinnert sich etwa an folgendes Ritual: Nach dem Tee führte die Hausherrin hinüber in die Galerie. Das Dienstmädchen reichte ihr ein rotes Samtetui samt silbernem Schlüssel. Damit ließen sich zwei Flügeltüren öffnen. Die gaben den Blick auf das höchst erotische Bild *Hoffnung* frei – es öffnete sich ein »Privatissimum«!

Ob Klimt die in seinen Zeichnungen häufigen lesbischen Szenen oder jene Frauen mit breit gespreizten Beinen, die Finger tief zwischen den Schenkeln, konsequent unter Verschluss hielt, ist bis heute ungeklärt. Einzig das Konvolut von fünfzehn hocherotischen Blättern, die 1907 vollendeten »Hetärengespräche«, fand nachweislich schon zu Klimts Lebzeiten Eingang in den Kunstbetrieb. Der Übersetzer des antiken Textes, Franz Blei, konnte in Klimts Atelier aus Stapeln von Zeichnungen auswählen – das Resultat war eines der schönsten Bücher des Jugendstils.

Über 4000 wunderbare Klimt-Zeichnungen sind erhalten, die erotischen Blätter meist Bleistift- oder Kohlearbeiten, gelegentlich kommen Farbstifte hinzu. Selbstvergessen räkeln sich die Körper. Doch selbst beim Masturbieren und in den Momenten der Ekstase bewahren die Modelle Haltung, eine Art schamloser Erhabenheit.

List of Works Illustrated / Verzeichnis der abgebildeten Werke

Front cover / Auf dem Einband: *Seated Nude / Sitzender Akt*, 1913, pencil,
56.9 x 37.3 cm, Graphische Sammlung der ETH Zürich, Zurich, see p. 50
Back cover / Rückseite: *Untitled / Ohne Titel*, 1914/15, pencil on Japanese paper,
55.8 x 36.7 cm, private collection, see p. 21

The Library of Congress Cataloguing-in-Publication data is available; British Library
Cataloguing-in-Publication Data: a catalogue record for this book is available
from the British Library; Deutsche Bibliothek holds a record of this publication in the
Deutsche Nationalbibliografie; detailed bibliographical data can be found under:
http://dnb.ddb.de

The Publisher would like to thank all museums and private collectors for providing
pictorial material for inclusion in this book.

Die Vorlagen wurden uns freundlicherweise von den in den Bildlegenden genannten
Museen und Sammlungen zur Verfügung gestellt bzw. stammen aus dem Archiv des
Verlags.

Prestel Verlag, Königinstrasse 9, 80539 Munich
Tel. +49 (89) 38 17 09-0; Fax +49 (89) 38 17 09-35
www.prestel.de

Prestel Publishing Ltd., 4 Bloomsbury Place, London WC1A 2QA
Tel. +44 (020) 7323-5004; Fax +44 (020) 7636-8004

Prestel Publishing, 900 Broadway, Suite 603, New York, NY 10003
Tel. +1 (212) 995-2720; Fax +1 (212) 995-2733
www.prestel.com

Concept: Eckhard Hollmann
Picture editing: Mirela Krämer
English translation: Paul Aston
Design and layout: Maja Kluy
Origination: LVD GmbH
Printing and binding: Print Consult, Munich/Grünwald

Printed in Slovakia on acid-free paper

ISBN 3-7913-3396-8